Brilliantly Vivid

COLOR-BY-NUMBER

Birds and Butterflies

Guided coloring for creative relaxation

30 original designs + 4 full-color bonus prints

Easy tear-out pages for framing

F. SEHNAZ BAC

Creative Publishing
international

Inspiring | Educating | Creating | Entertaining

Brimming with creative inspiration, how-to projects, and useful information to enrich your everyday life, Quarto Knows is a favorite destination for those pursuing their interests and passions. Visit our site and dig deeper with our books into your area of interest: Quarto Creates, Quarto Cooks, Quarto Homes, Quarto Lives, Quarto Drives, Quarto Explores, Quarto Gifts, or Quarto Kids.

First Published in 2016 by
Creative Publishing international,
an imprint of The Quarto Group,
100 Cummings Center,
Suite 265-D, Beverly, MA 01915, USA.
T (978) 282-9590 F (978) 283-2742
QuartoKnows.com

Creative Publishing international titles are also available at discount for retail, wholesale, promotional, and bulk purchase. For details, contact the Special Sales Manager by email at specialsales@quarto.com or by mail at The Quarto Group, Attn: Special Sales Manager, 100 Cummings Center, Suite 265-D, Beverly, MA 01915, USA.

10 9 8 7 6

ISBN: 978-1-58923-946-3

Design: Sylvia McArdle
Cover Image: F. Sehnaz Bac
All artwork and photos: F. Sehnaz Bac, except for page 10 (Shutterstock)

Printed in Canada

About the Author

An archeologist by training, artist **F. Sehnaz Bac** is celebrated for her radiantly colorful and charming painted stones, which are available through her Etsy shop *I Sassi Dell'Adriatico* (The Adriatic Stones). She lives in Alba Adriatica, Italy, a small town on the Adriatic Sea. To see more of Sehnaz's work, visit her Facebook page *I Sassi Dell'Adriatico* by Sehnaz Bac.

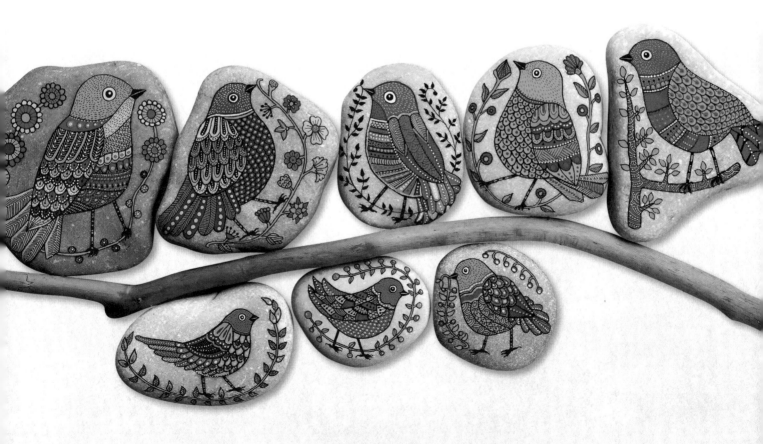

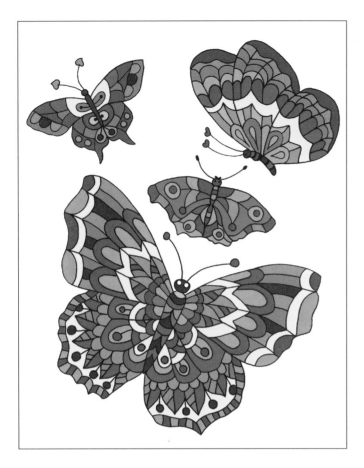
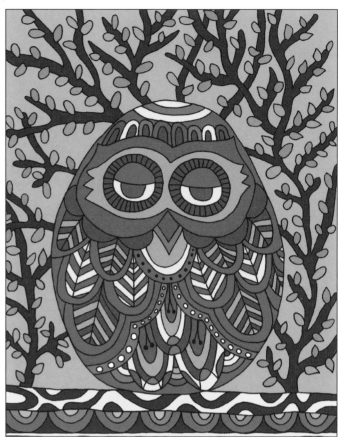
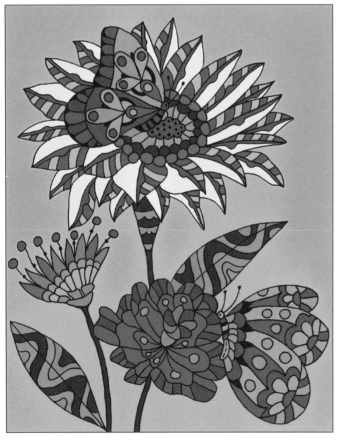
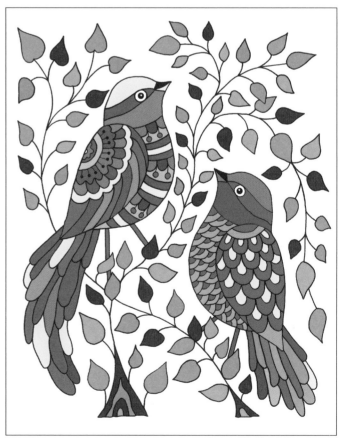

Contents

A Spark of Creativity

As much as art has become a big part of my life today, while growing up in Istanbul, Turkey, I didn't aspire to be an artist. However, I was raised in a house full of wonderful works of art, and I always loved to draw. My parents were great admirers of the creative arts: My father enjoyed collecting art and my mother used to crochet and knit (I still have her beautiful and colorful creations). My parents were also keen travelers, introducing me to the natural and cultural beauty of new places. Thanks to them, I was exposed to the remains of many of the world's great ancient civilizations, and this inspired me to pursue a career in archaeology.

After studying archaeology at Ege University in İzmir, Turkey, I went on to earn a masters degree in restoration and conservation at the Faculty of Architecture. Throughout this time I continued to foster my creative side by drawing and painting. Fortunately, when I became an archaeologist, I was able to find a way to combine archaeology and drawing, creating works that were sometimes technical and at other times more artistic. Many of these drawings would be published in various scientific journals. For the next twenty-three years I worked as an archaeologist and draftsman in the field at excavations in Turkey with both local and foreign excavation teams.

My life changed dramatically about ten years ago, when I was diagnosed with lymphoma. The illness and subsequent recovery occupied my every moment for the next five years. After two transplantations of stem cells and an experimental treatment, I was finally slowly able to return to some semblance of a normal life. During this period I would take long walks along the beach on the Adriatic coast of Italy, where I live. As most beachcombers do, I began collecting stones and shells that caught my eye along the water's edge. These first found objects lit a spark of creativity inside of me, and I began painting on them, drawing inspiration from nature and the colors that surrounded me.

Presenting myself to the world as an artist took some time, as I had worked for so long as an archaeologist. Though I had been painting and drawing purely for myself all along, painting on these weathered natural creations evolved from a type of therapy into a passion for me.

Inspiration and Imagination

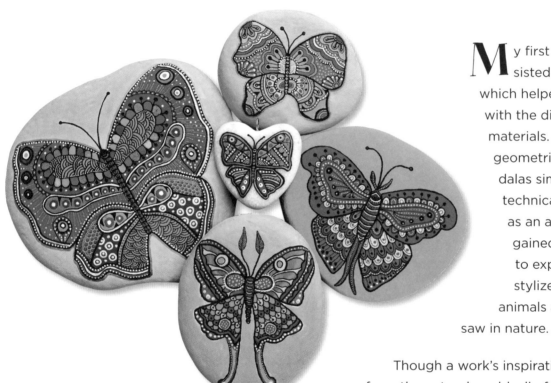

My first stone paintings consisted of simple designs, which helped me learn to work with the different surface and materials. These were flowers, geometric motifs, and mandalas similar to the fine-lined technical drawings I had done as an archaeologist. As I gained proficiency, I began to experiment with more stylized representations of animals and other designs I saw in nature.

Though a work's inspiration may be drawn from the natural world, all of my designs come from my imagination. Having lived in different places and been lucky enough to have traveled as much as I have, I'm able to filter and mix a host of cultural influences. The result is something totally unique and exactly as I had imagined it. The technical drawings of pottery and ceramic fragments I had done at excavations really helped me develop and improve my eye for observing fine detail.

My innate curiosity and imagination are what really inspire me to create these colorful and detailed artworks. And archaeology's influence certainly plays a role—that desire to always learn and unearth something new. I'm still figuring out how to see things with different eyes, without relying on standard forms, colors, or rules to draw and paint. It makes me think and feel in a different way, and I believe it helps me a great deal in increasing my creativity. I love to see my owl design that I drew and painted, and think: I didn't make an owl; I made *my* owl! I love the feeling of knowing

there is no other owl like this in nature or in any other kind of artwork.

I like to use acrylic paints and acrylic/India inks, and I utilize different kinds of pens and varnish to seal the work. The designs I come up with are always drawn freehand directly on the stone, which I paint with a base color. Or I simply draw the design onto the natural surface of the stone with a pencil. For the most part, I won't sketch the design out on paper, as long as it isn't a very complicated one. When I do one of my linear mandalas I never sketch on the stone, I start directly with ink. My favorite designs are the mandalas as well as birds.

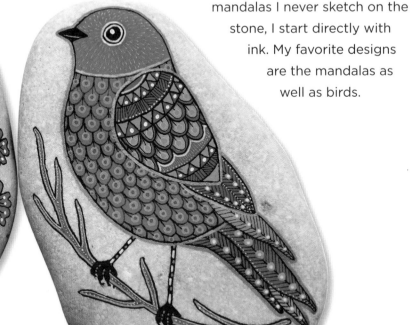

Joyful Color

During my illness, when I was hospital-ized for long periods, I was always searching for color. Often I would take colorful objects with me into the hospital, and they had a very positive effect on me. When I was able to return to a normal life, I continued to use this "color therapy," in my home, in my clothes—the more color, the better. When I resumed painting, these color preferences transferred to my work.

Bright colors especially have the most positive effect on me. I'll use bright and bold colors re-gardless of whether they go with one another. This imbues a sense of freedom and joy in my work. When I first started to paint on stones with these colors, I noticed it had the same effect on the peo-ple around me. And when my works were shown on social media, people said they felt better, forgot their problems, and were able to start their day happy. The bright colors allow me to see a design, such as an owl, as I want to see it, not as it might exist in nature.

I hope you'll approach these designs in the same way—with freedom and joy. By using bright and bold colors without worrying about whether they go together, you'll enjoy your coloring experience more fully, which will lift your mood and have a positive effect on your life in general.

COLORING MEDIUMS

The palette for this book is inspired by the paints and inks I use for my stones. You have several options for coloring: dry mediums like colored pencils, markers, or crayons; or wet mediums like watercolor pencils, pan or tube watercolors, or bottle or tube acrylics.

If you use a wet medium, remove the template so the color won't bleed through the back onto another. Precisely painting the more intricate spaces may prove challenging, so feel free to apply washes over larger areas.

Each medium will give you a different look, from soft to vivid, but the color combinations will always be radiant.

Color Number Key

These are the 25 colors I used to color the designs in this book. As you work on the templates, simply color in each numbered space with the corresponding color below. For small spaces where no number is indicated, you can choose any of the colors in this vivid palette. Once you've completed a few of the designs, you may want to explore your own creative path and fill the spaces with any of the colors below, or even use your own palette. Enjoy!

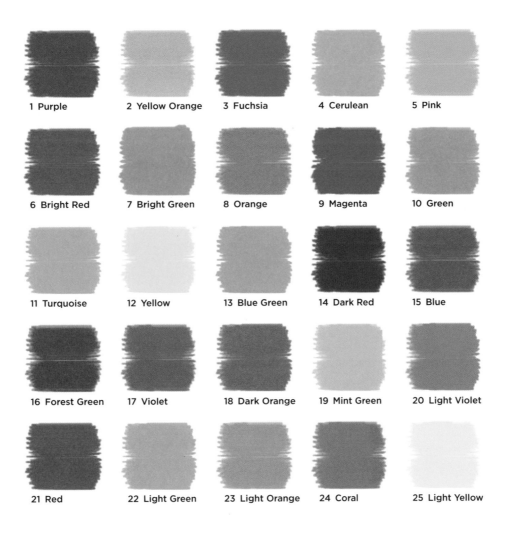

1 Purple 2 Yellow Orange 3 Fuchsia 4 Cerulean 5 Pink

6 Bright Red 7 Bright Green 8 Orange 9 Magenta 10 Green

11 Turquoise 12 Yellow 13 Blue Green 14 Dark Red 15 Blue

16 Forest Green 17 Violet 18 Dark Orange 19 Mint Green 20 Light Violet

21 Red 22 Light Green 23 Light Orange 24 Coral 25 Light Yellow

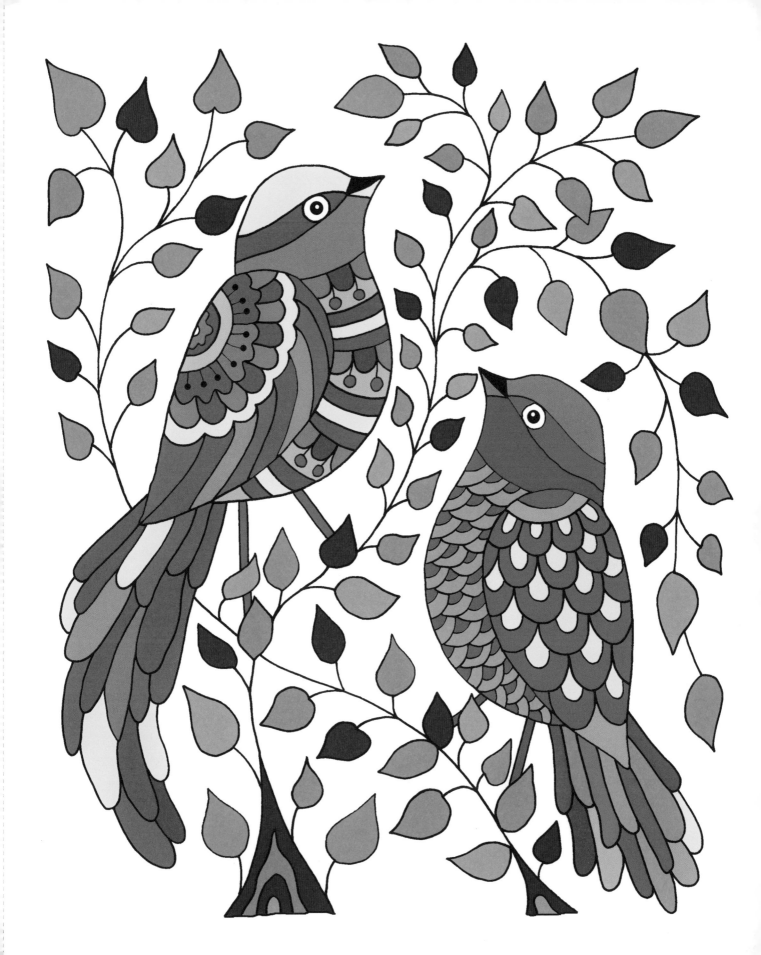

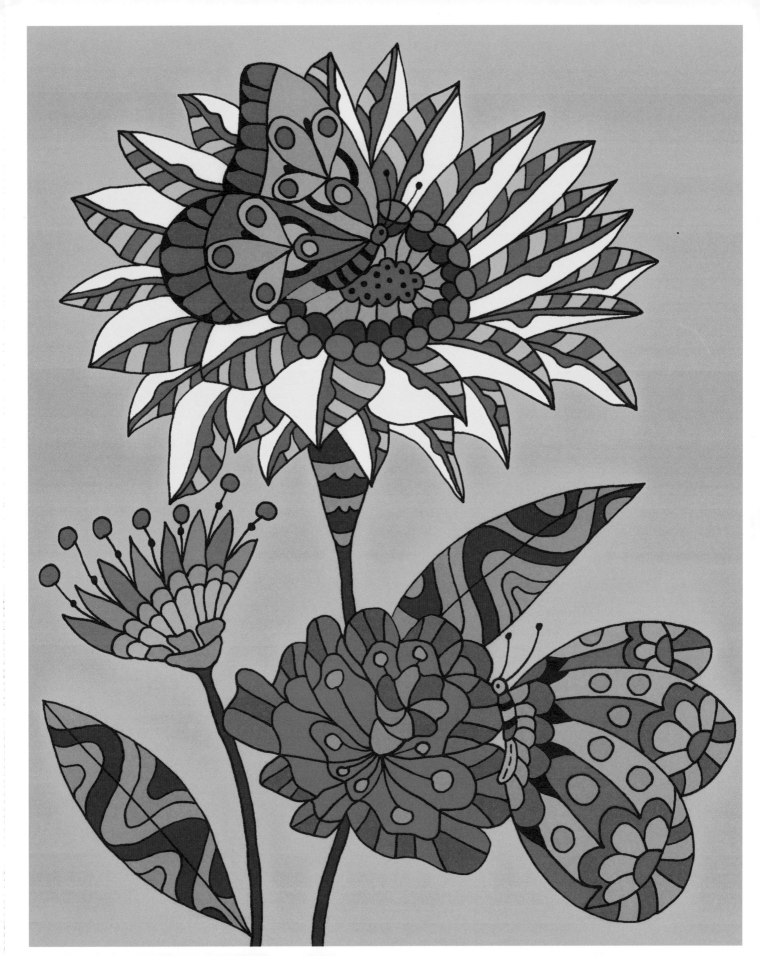

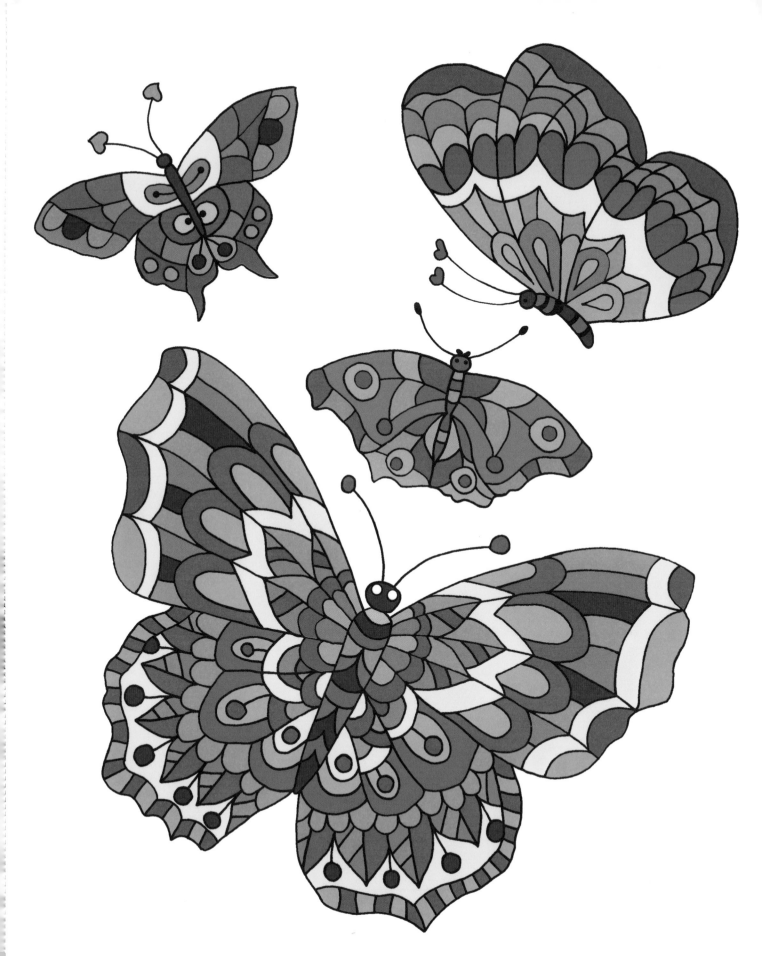

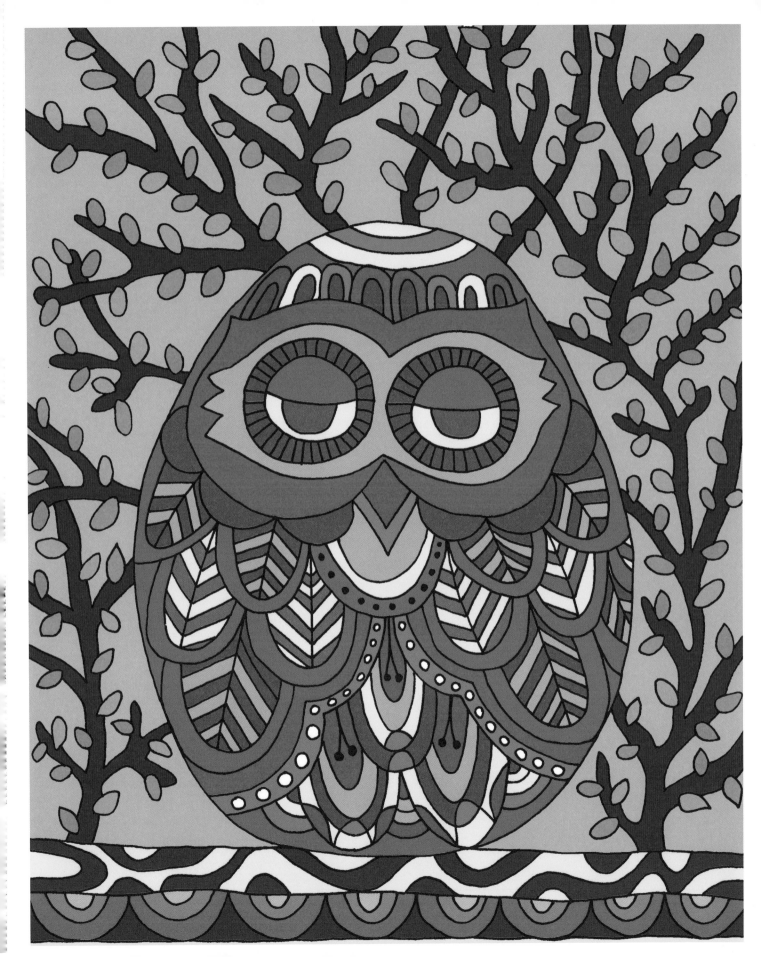

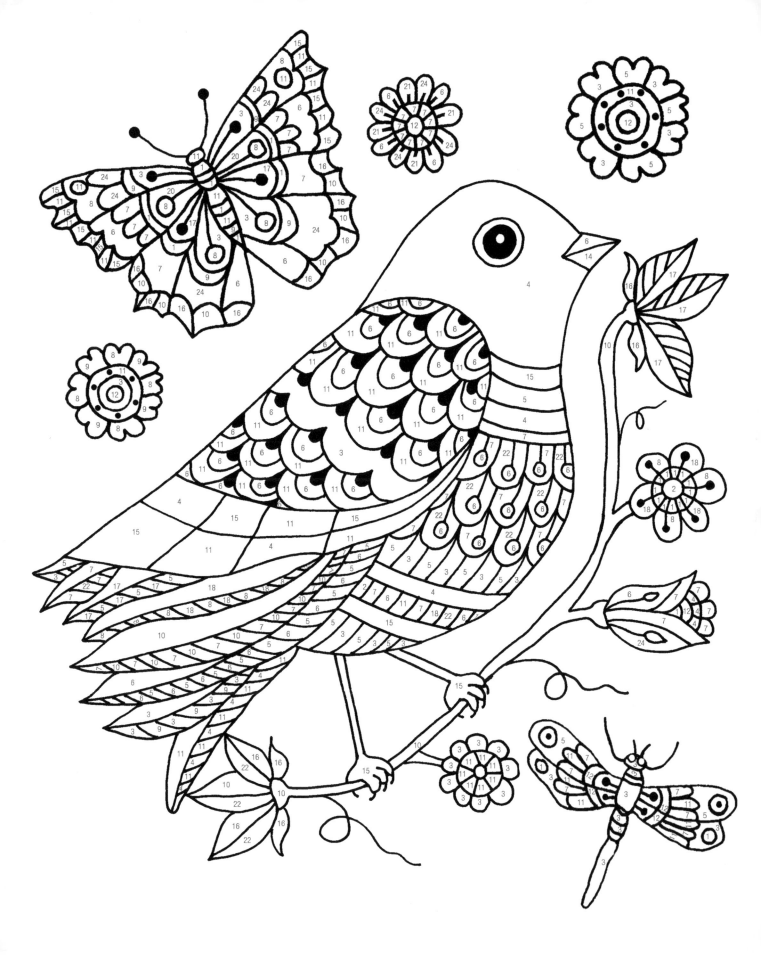

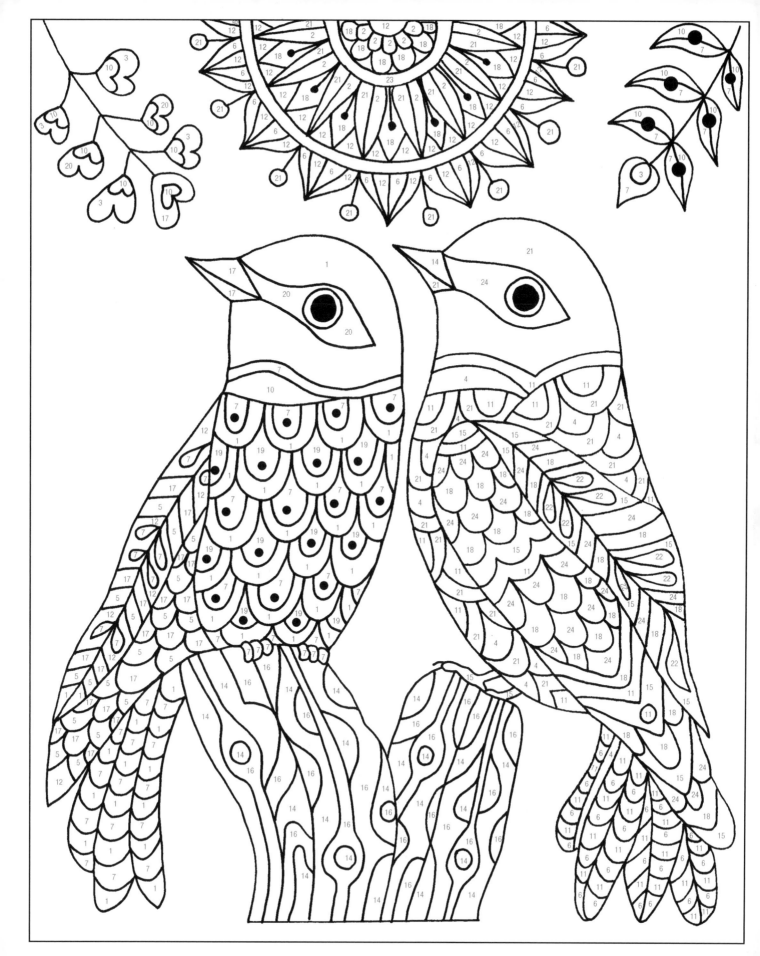

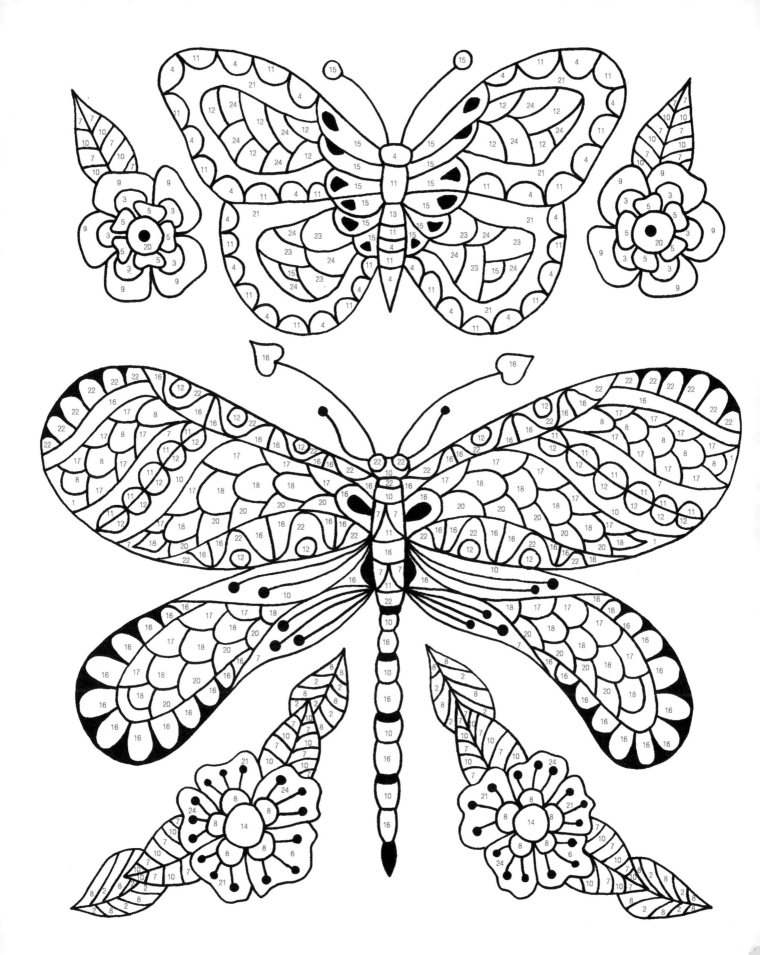

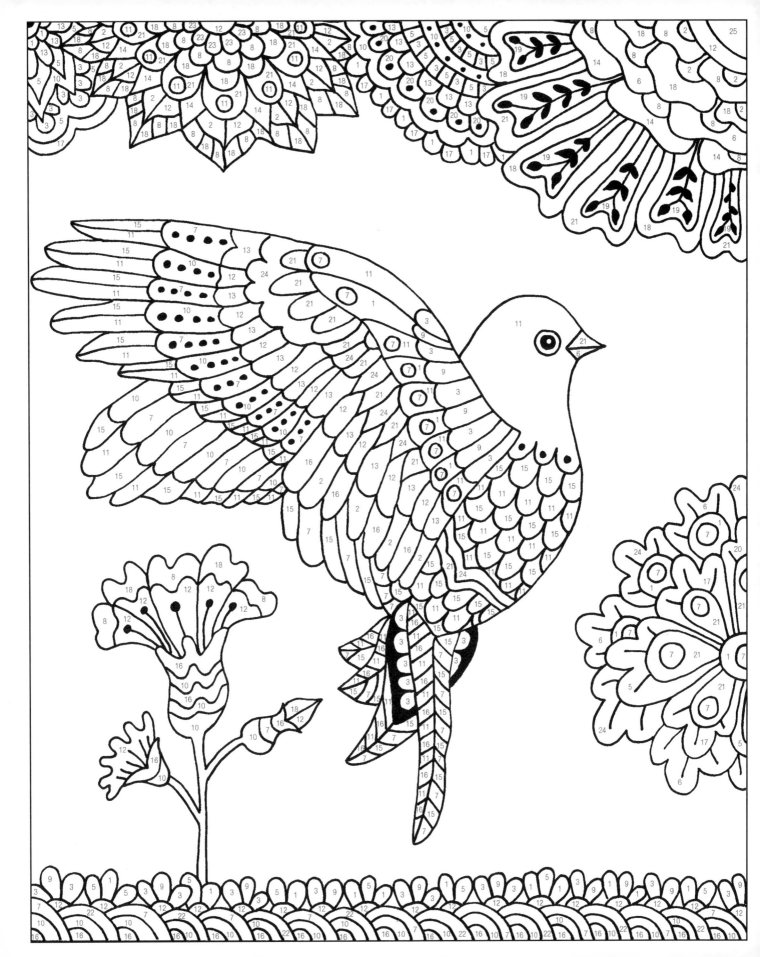

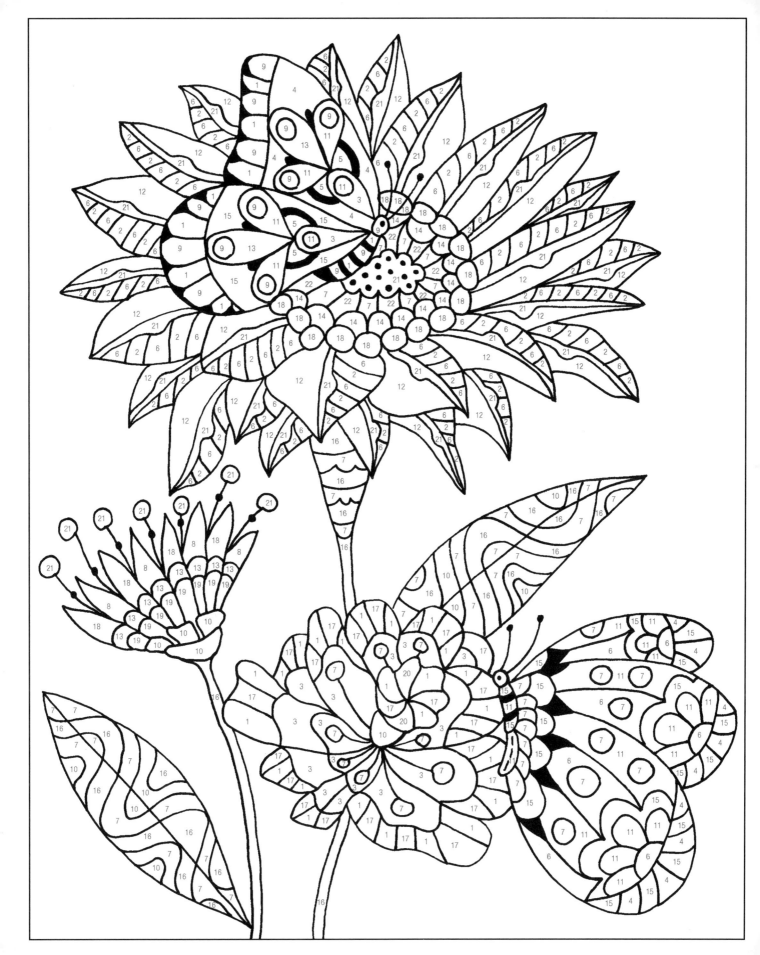

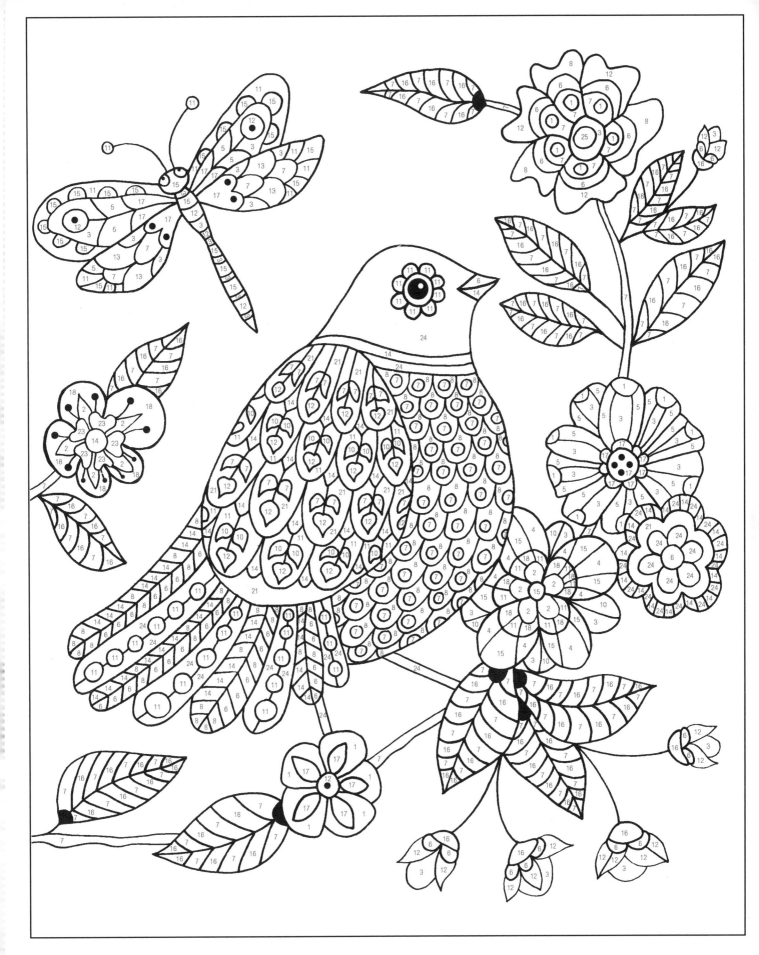

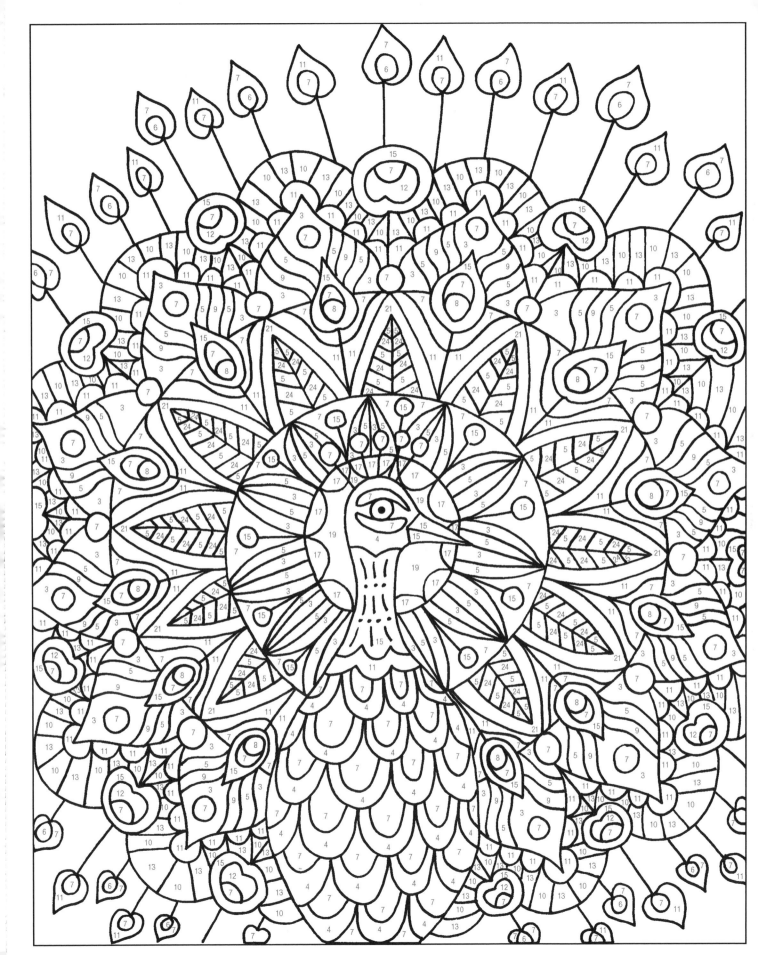

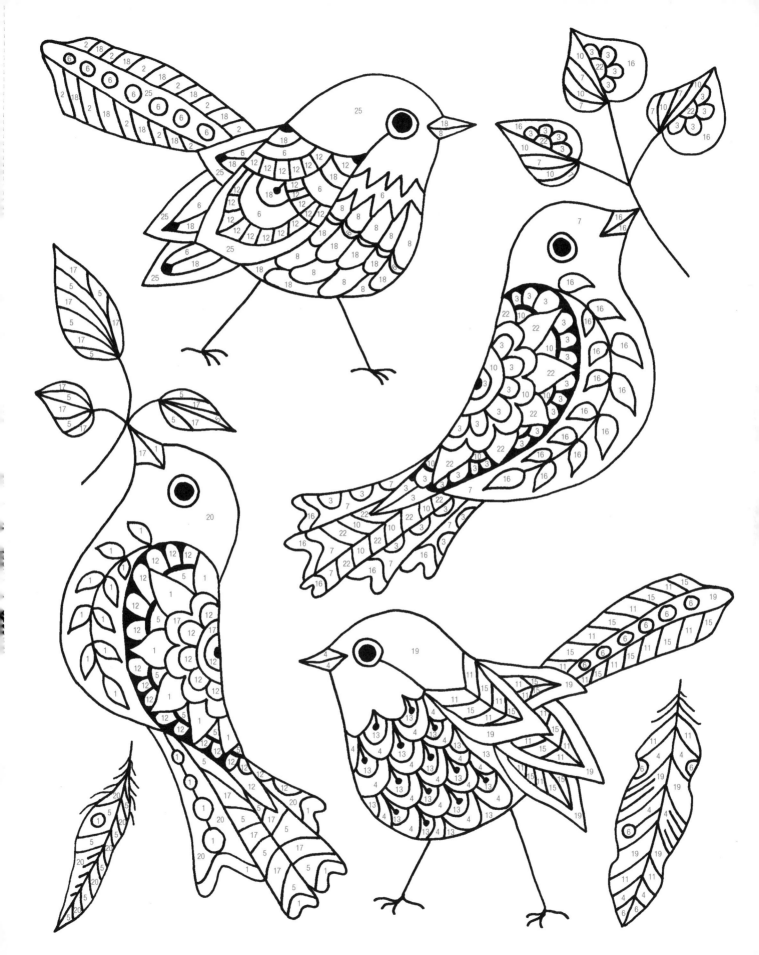

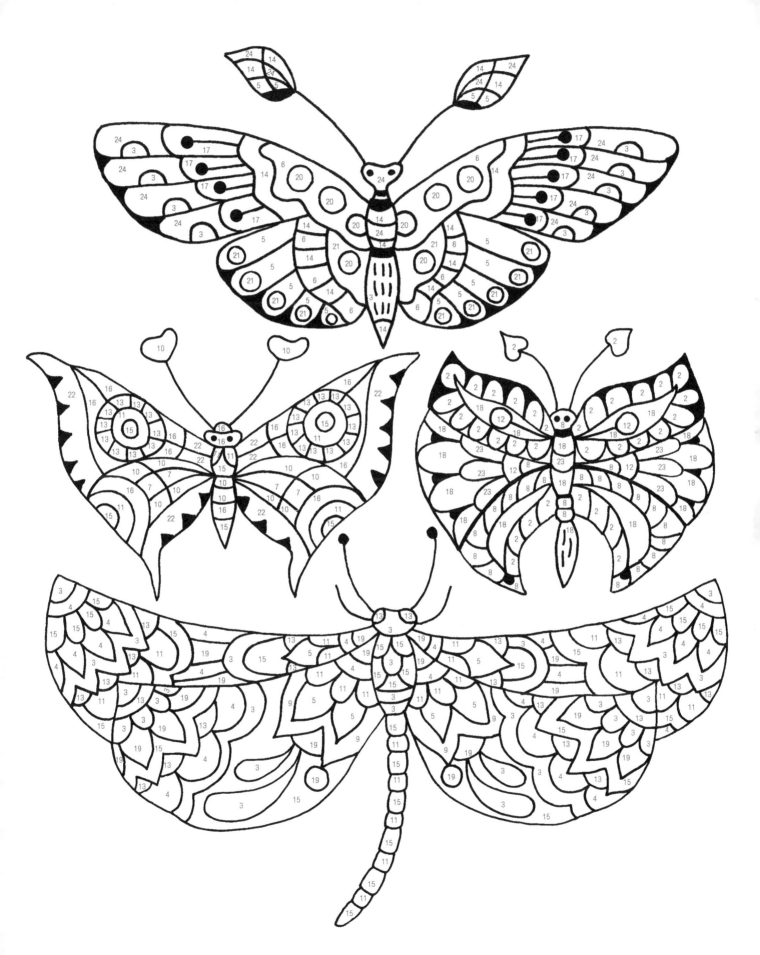

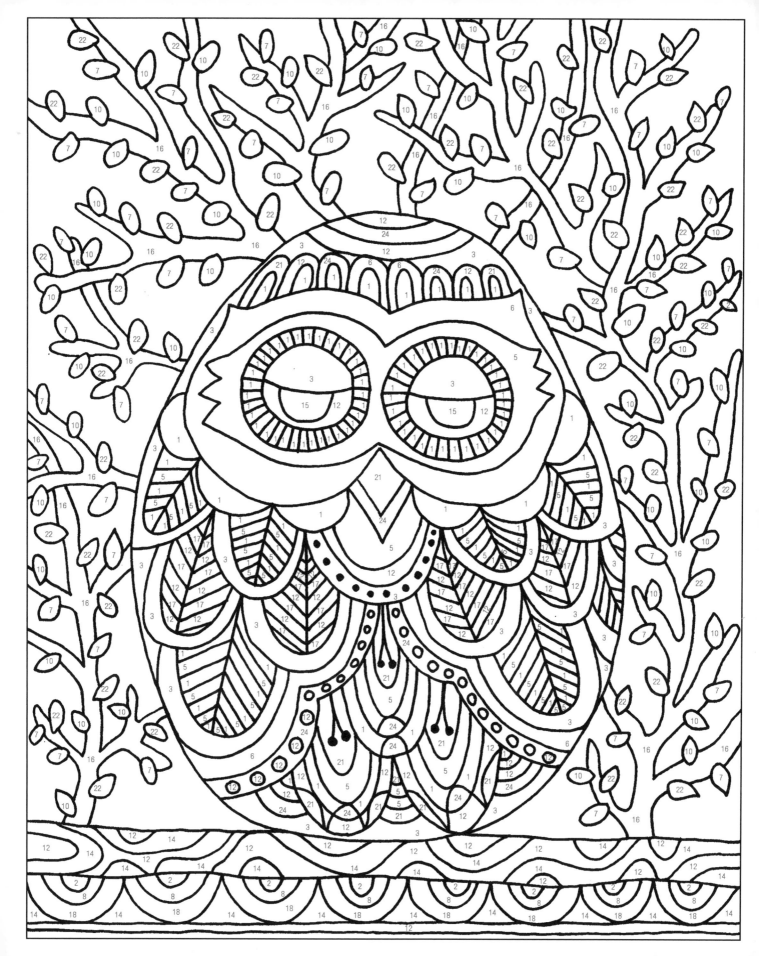

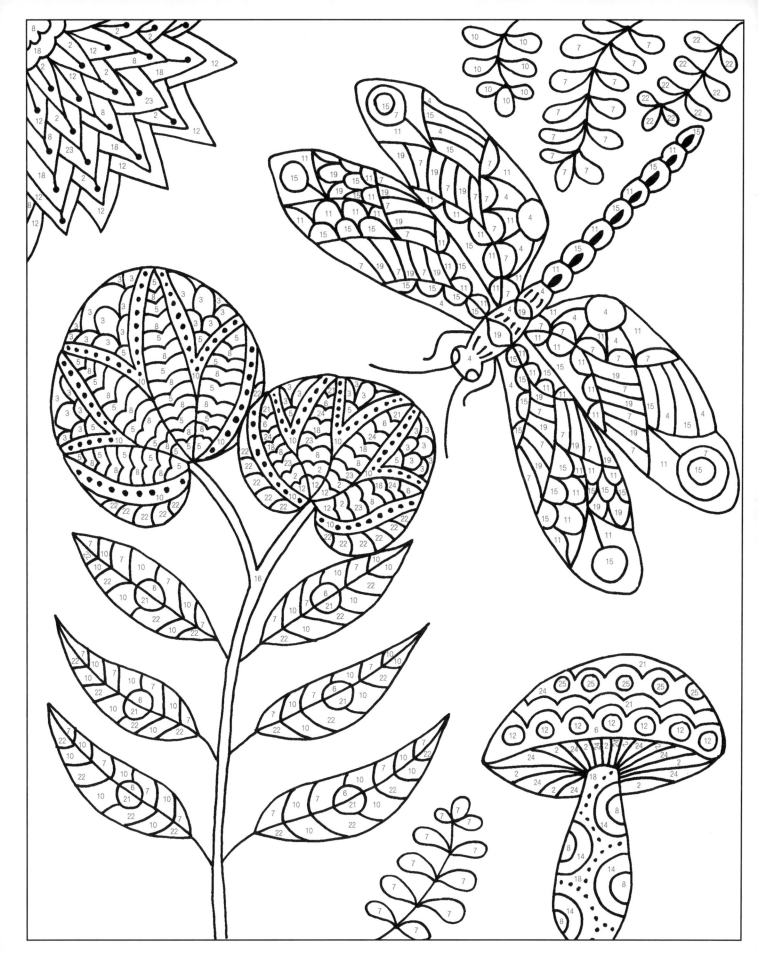

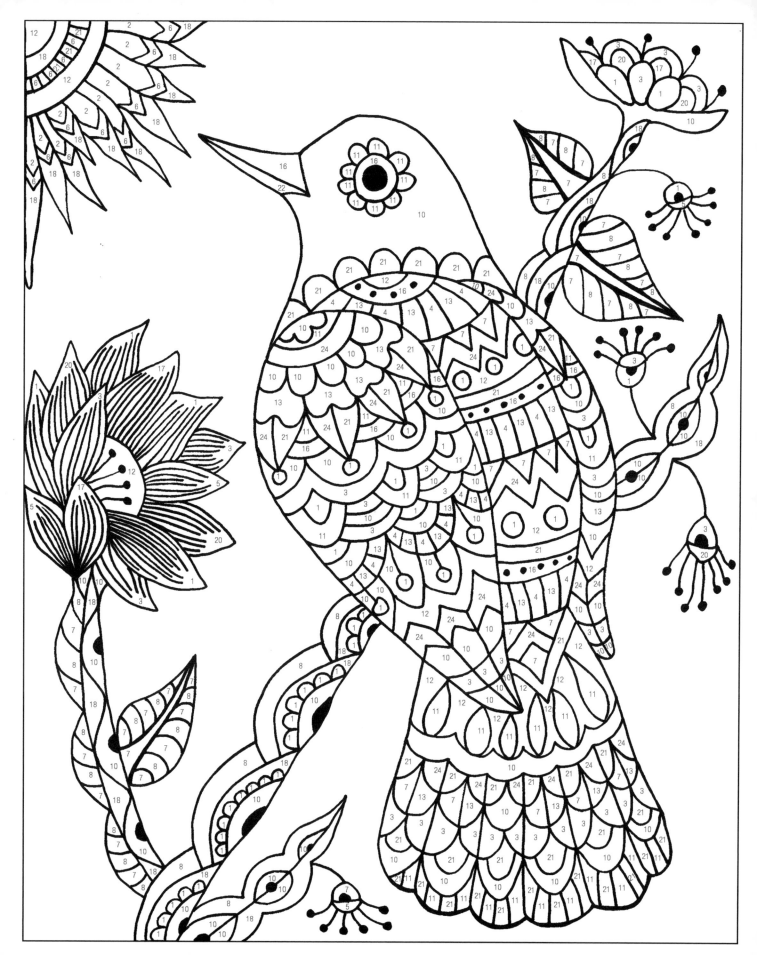

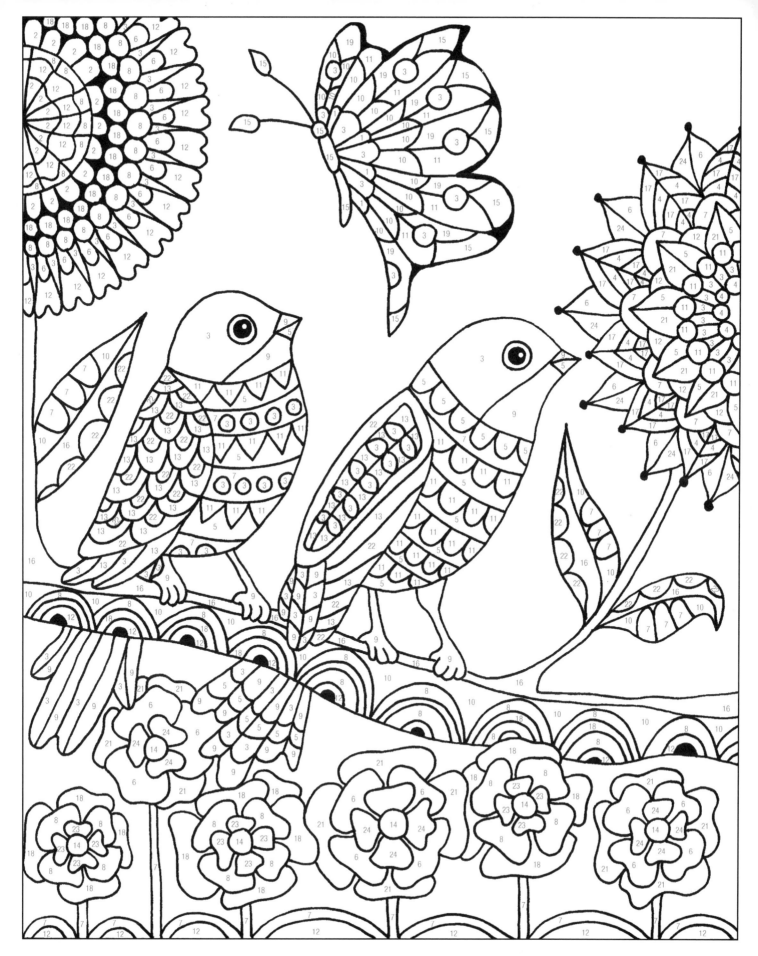

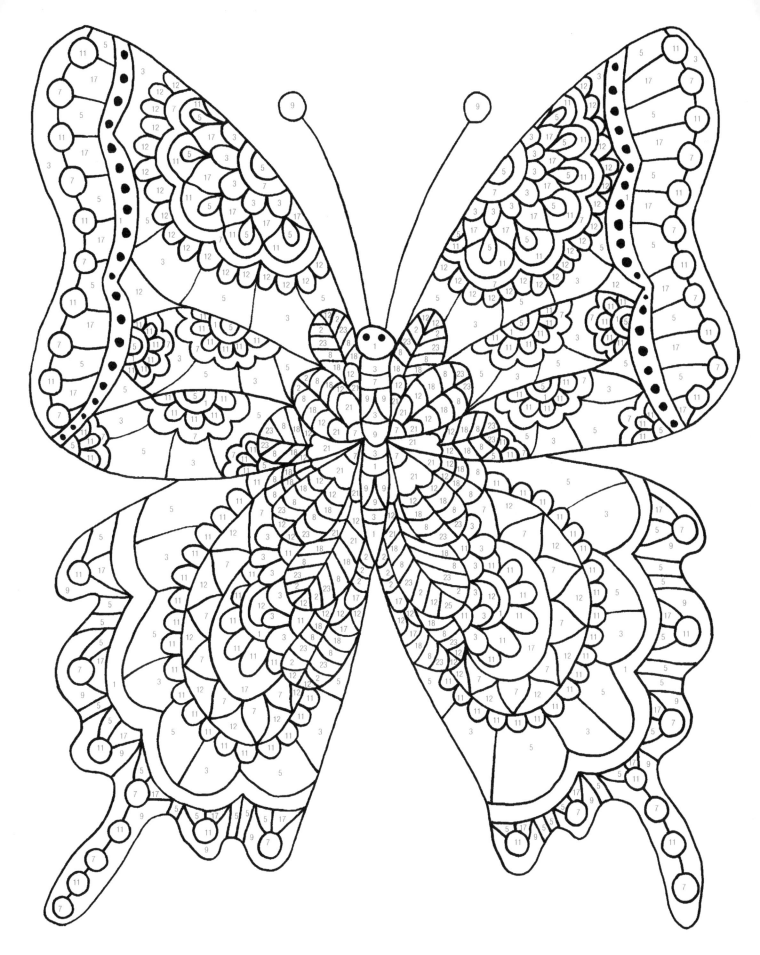

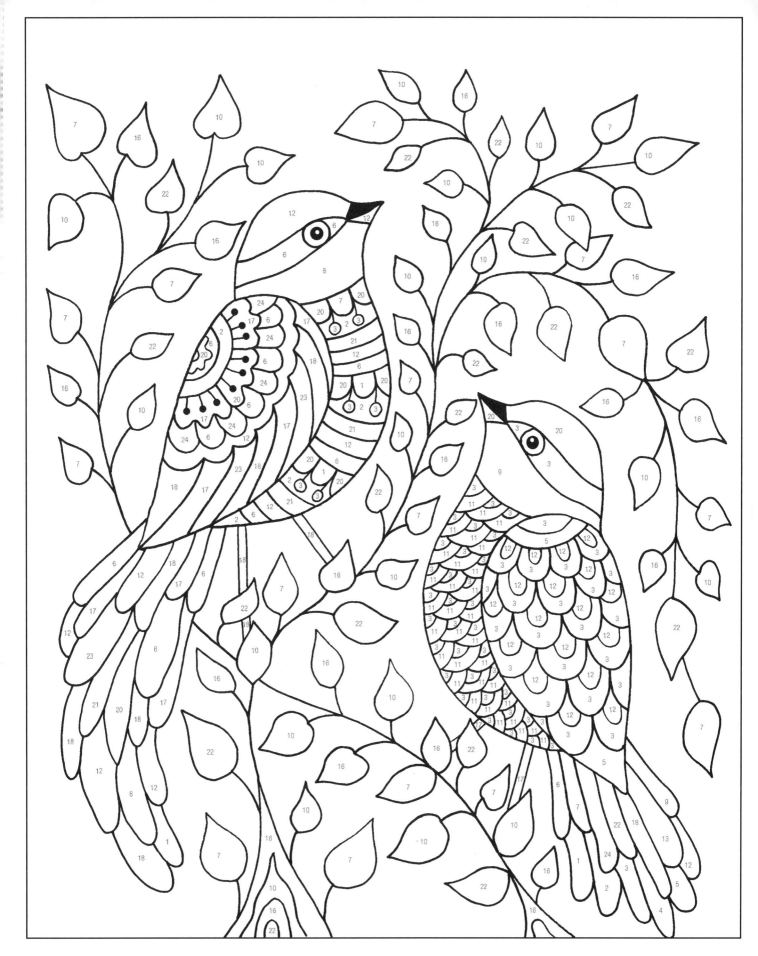

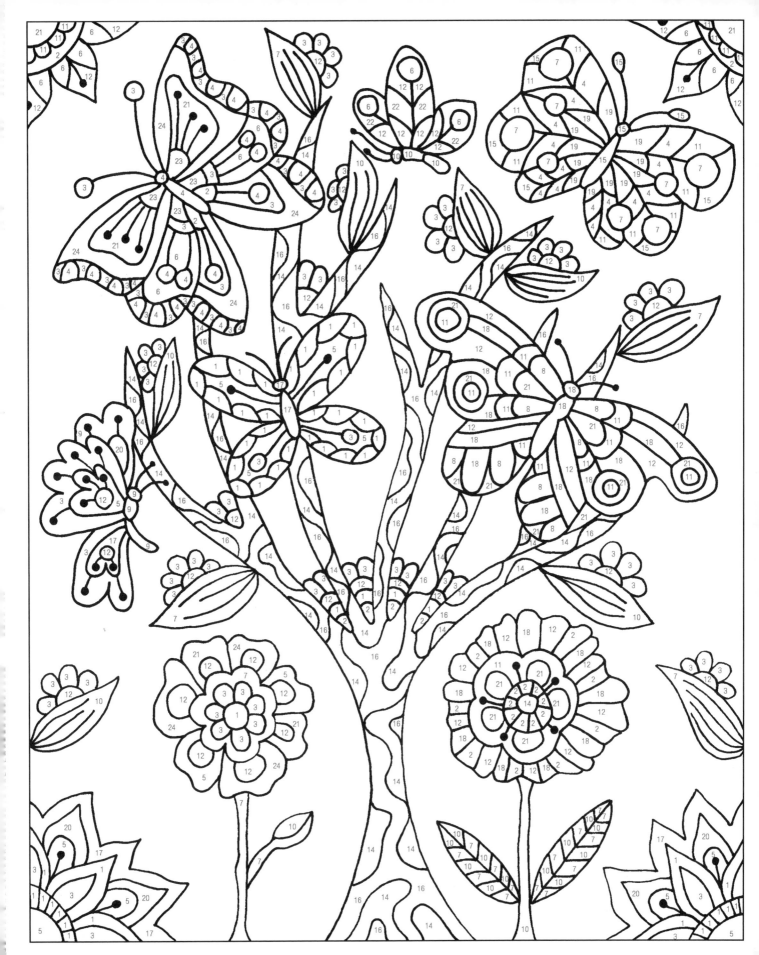

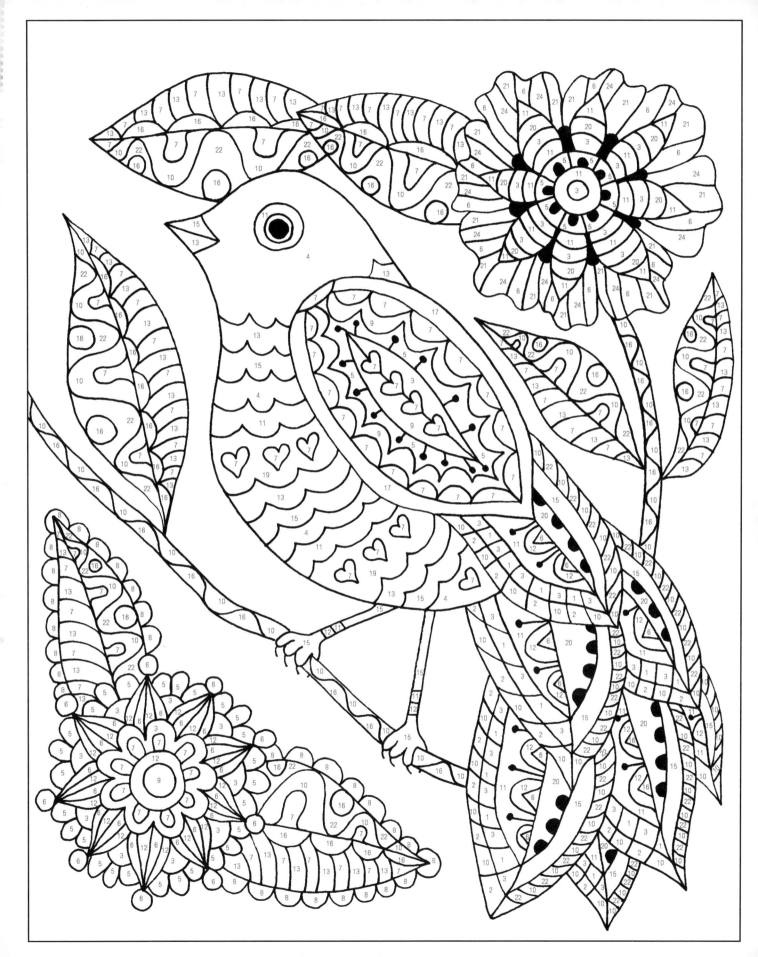

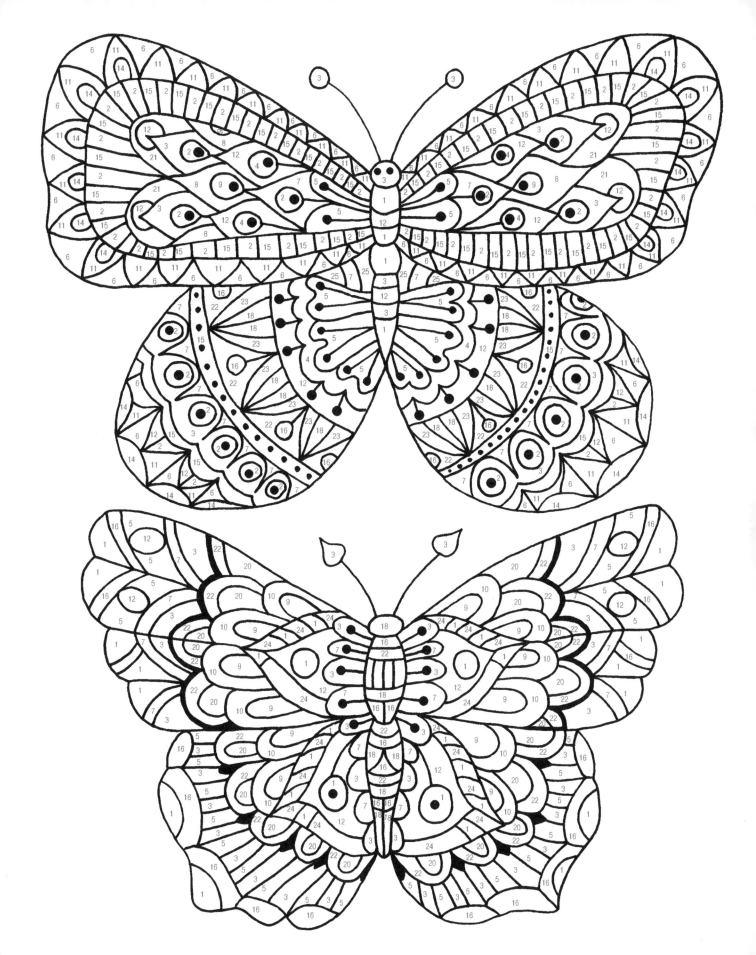

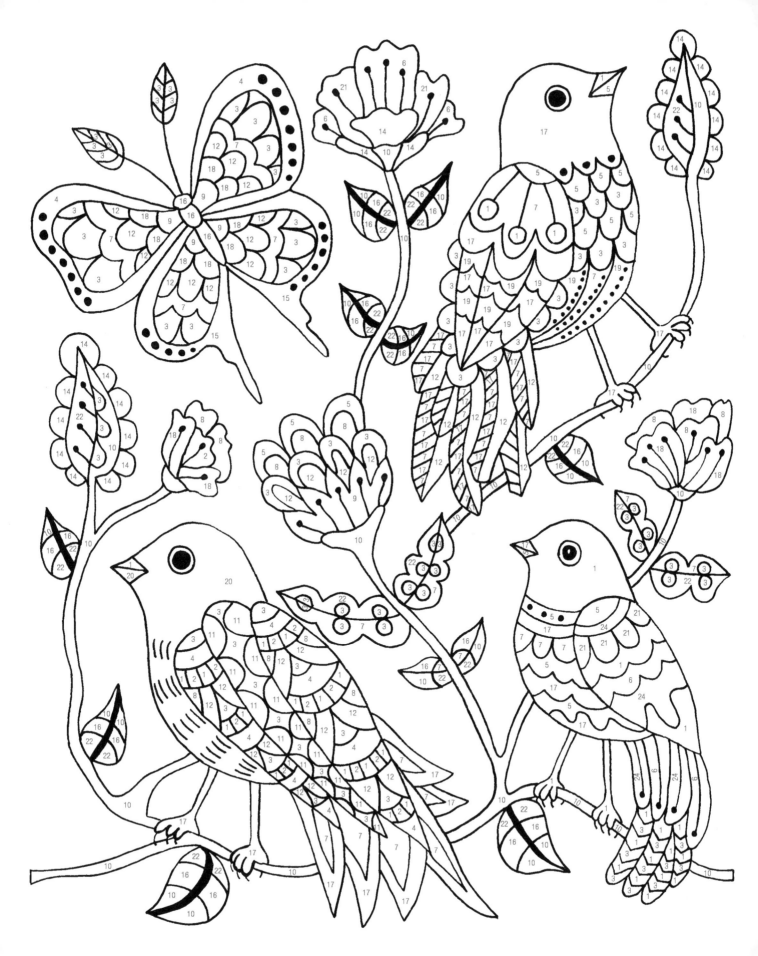

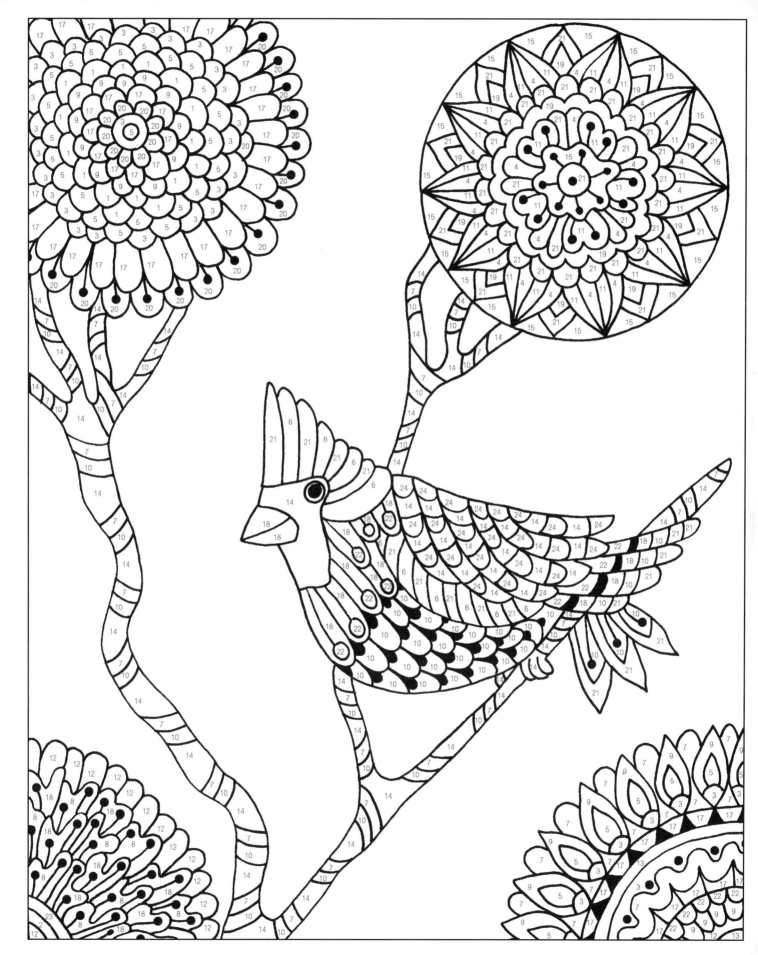

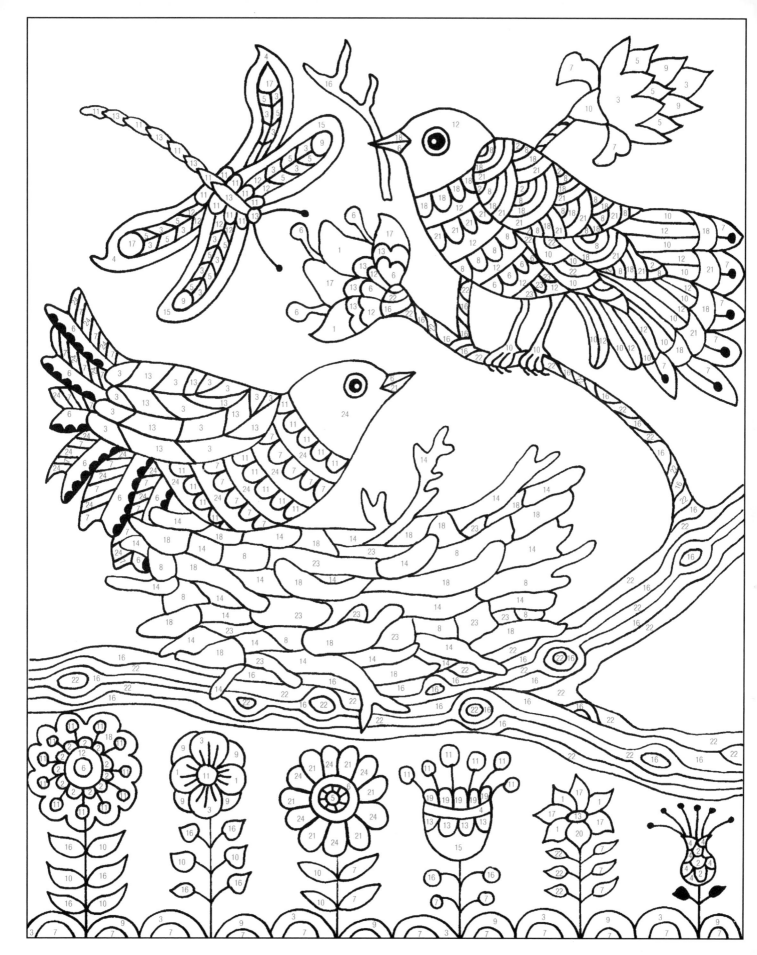

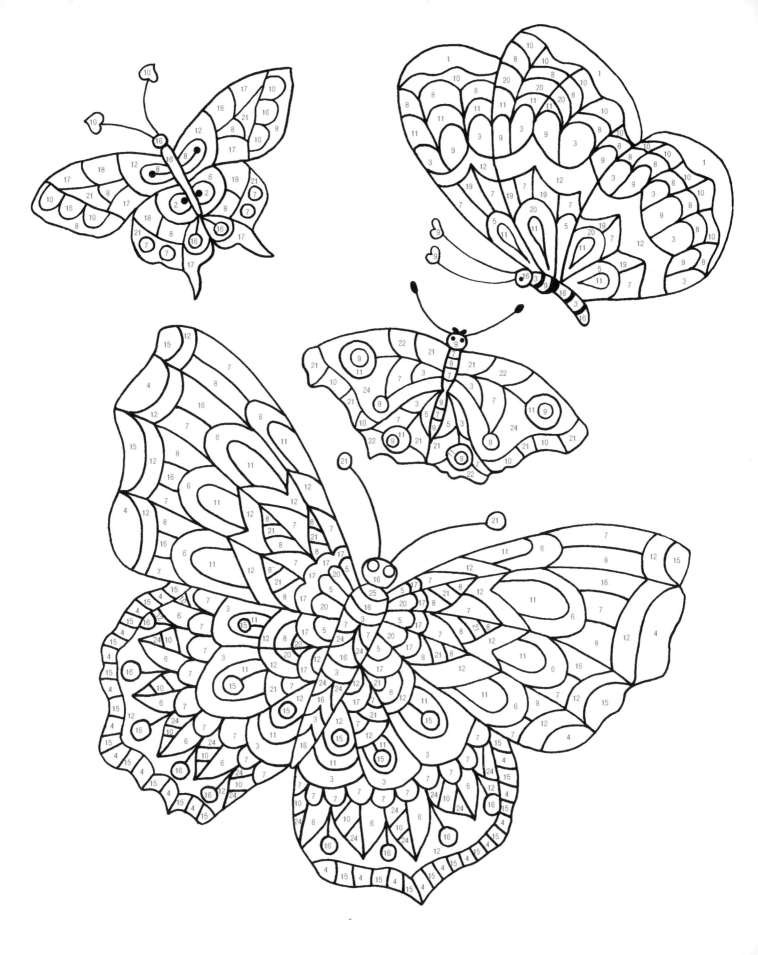

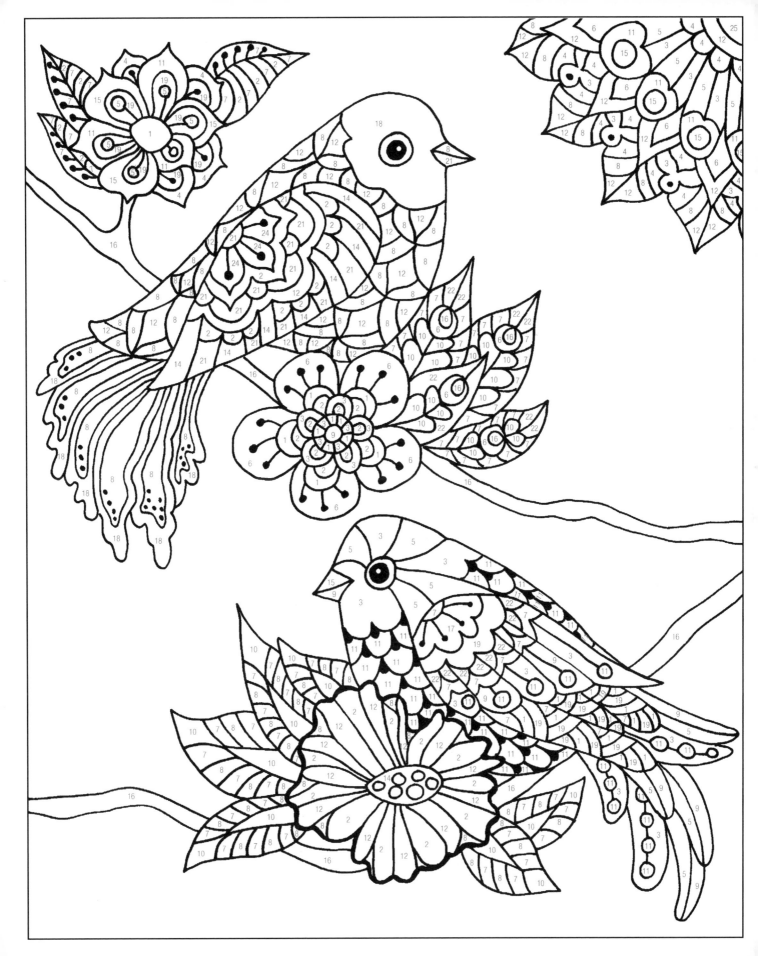

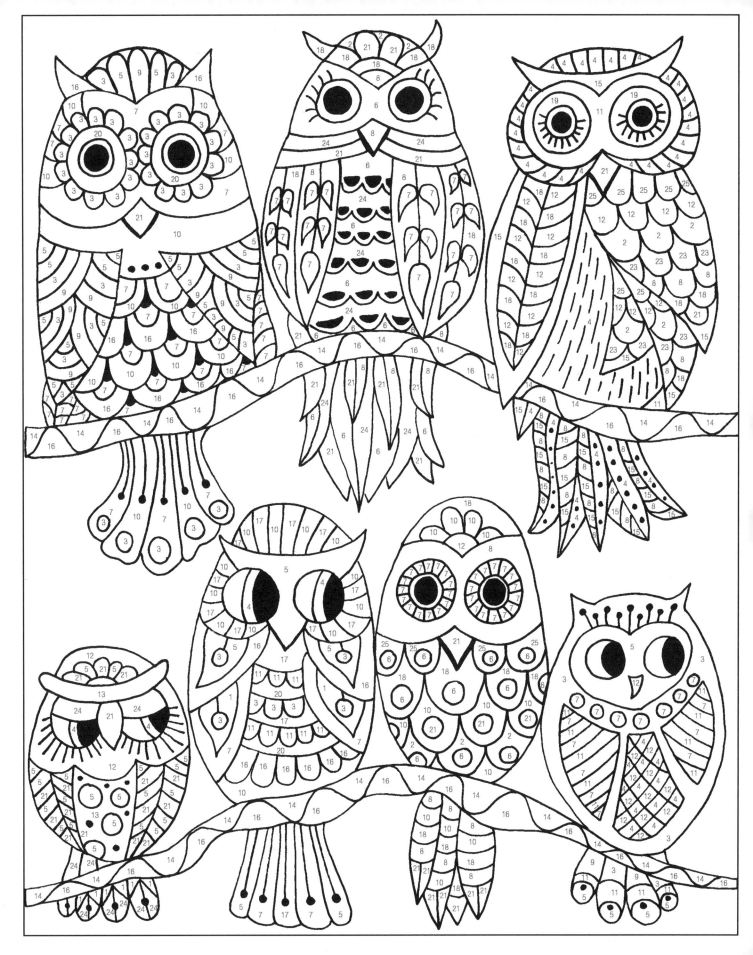

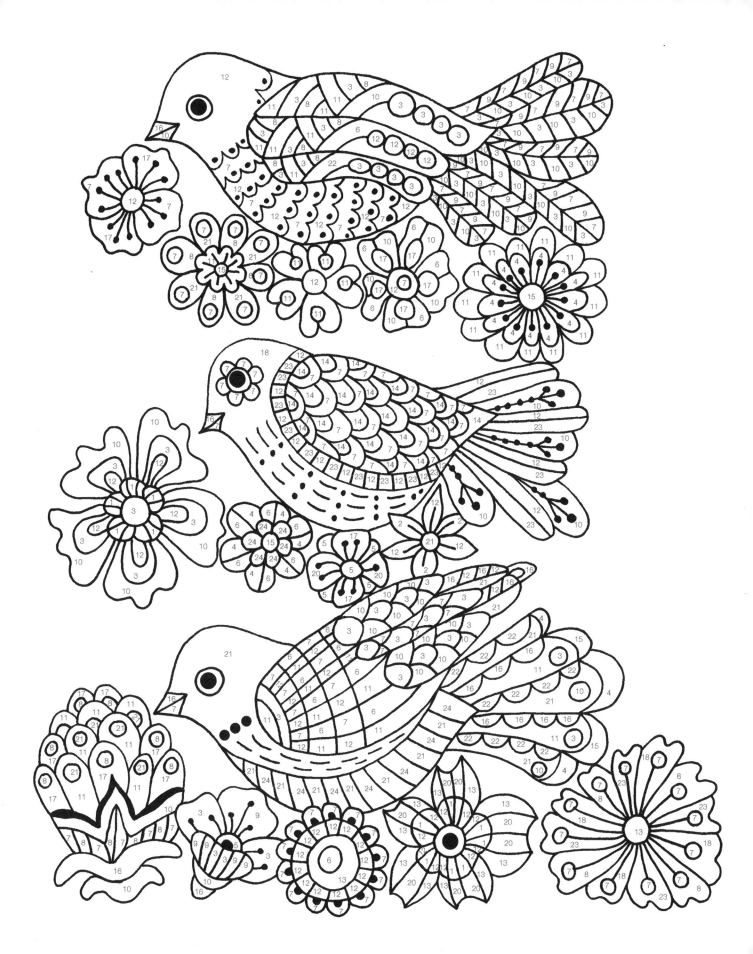

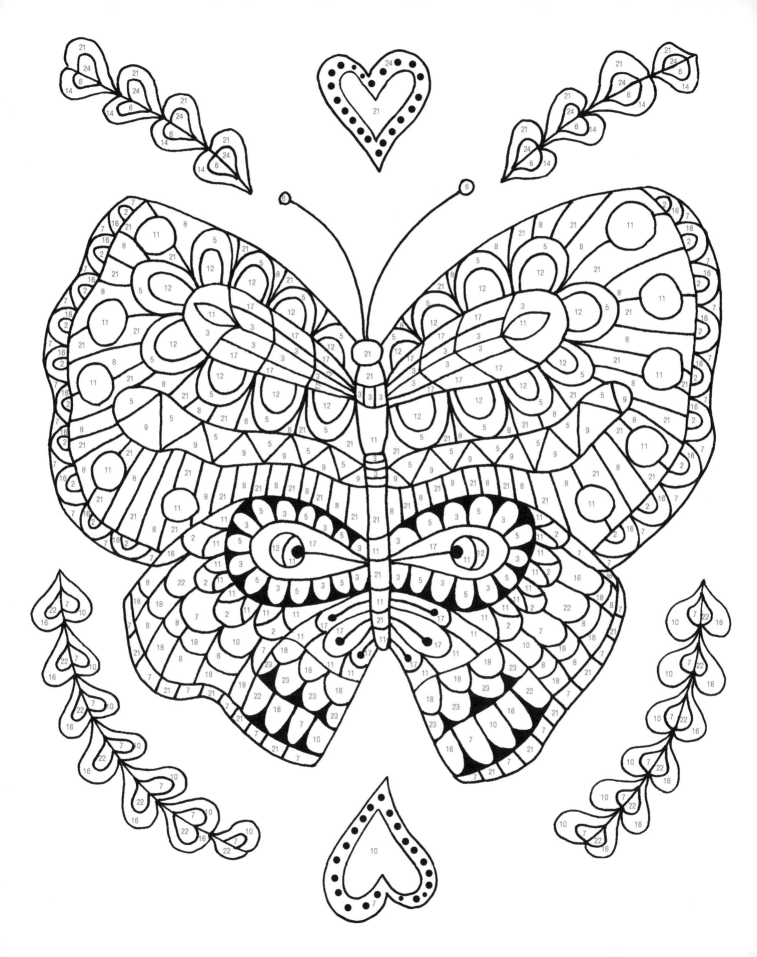

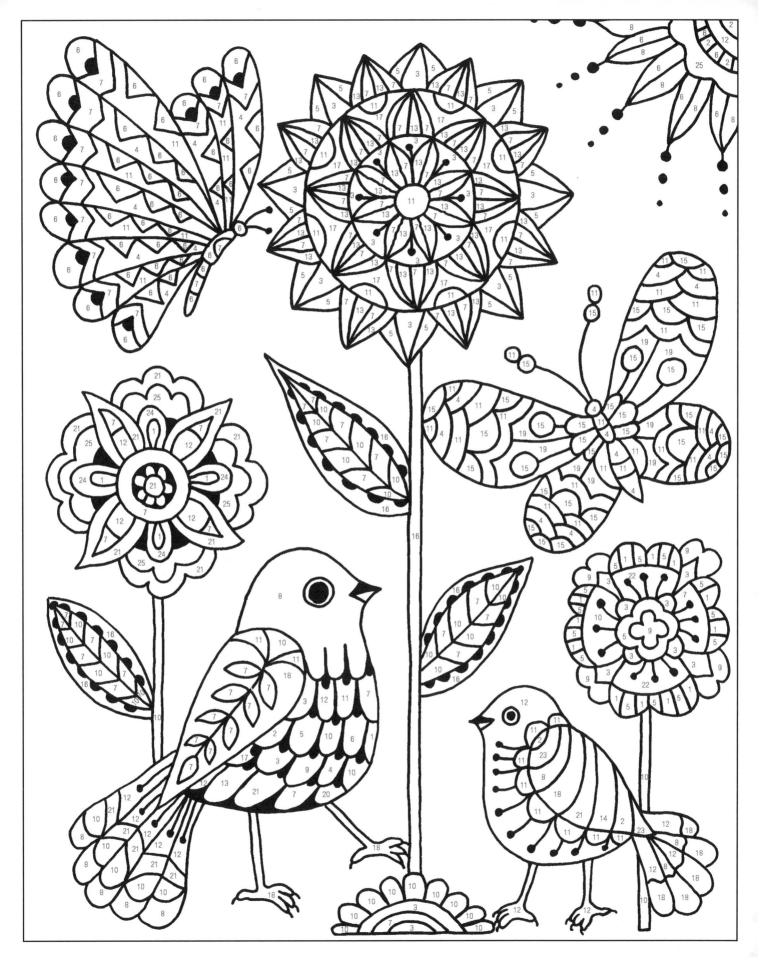

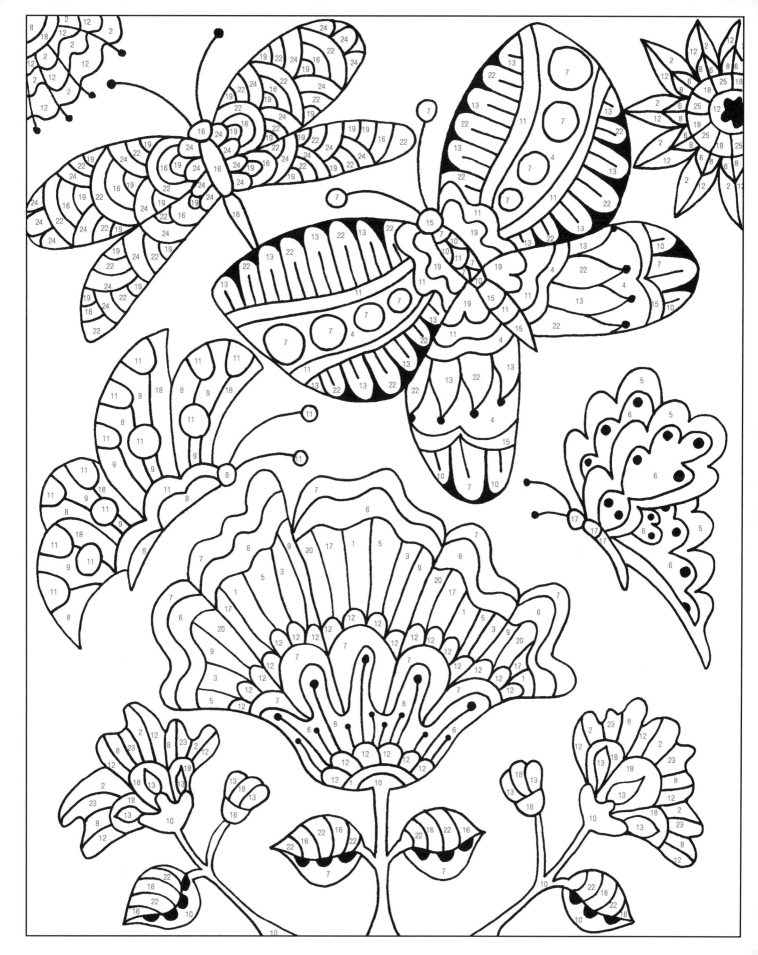

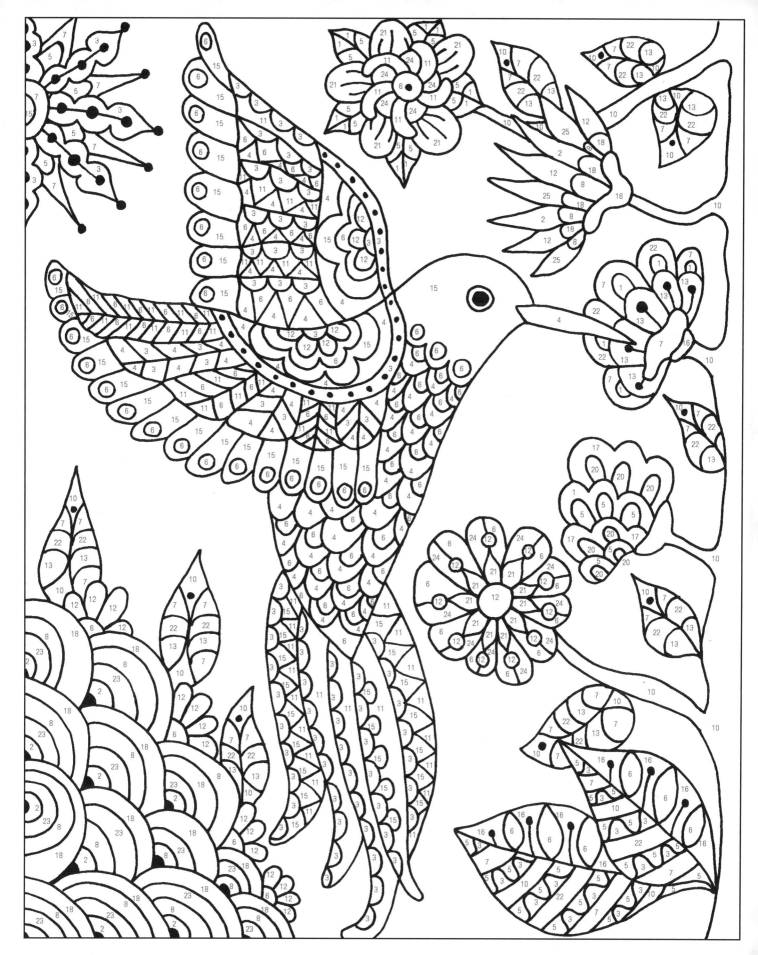

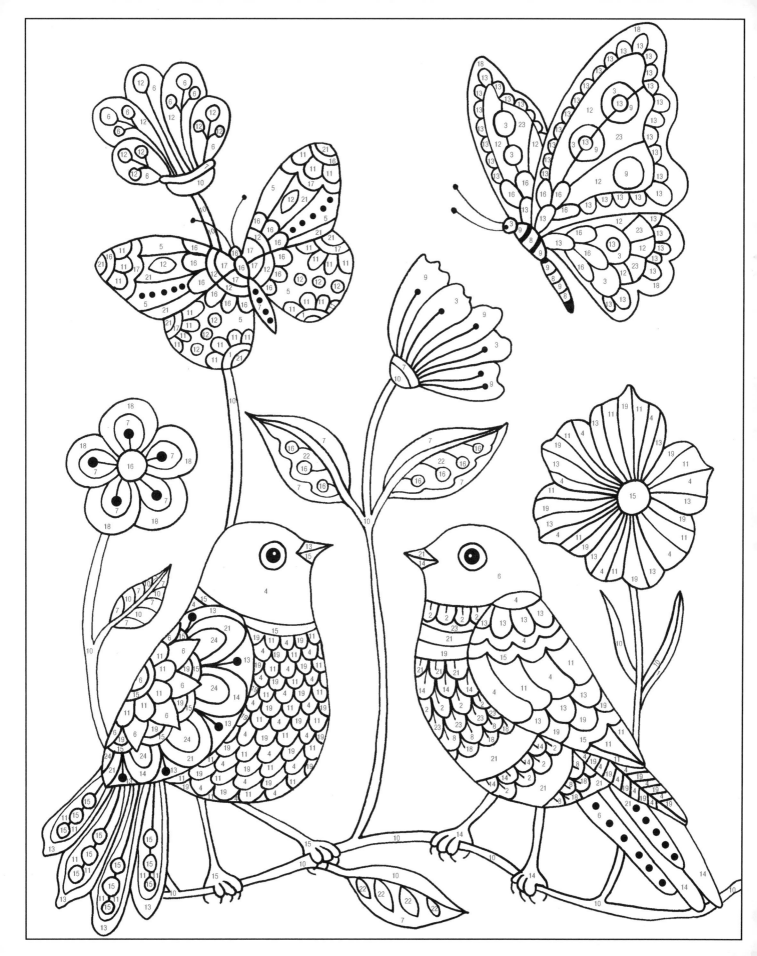